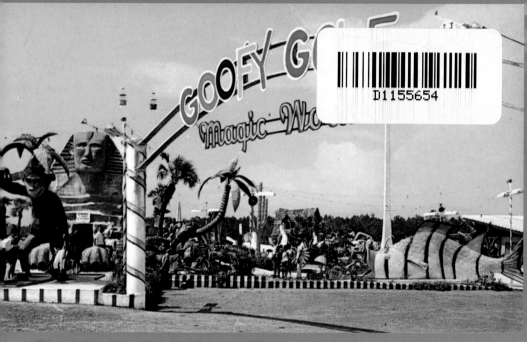

The Minibook of Minigolf

SEASIDE PUBLISHING

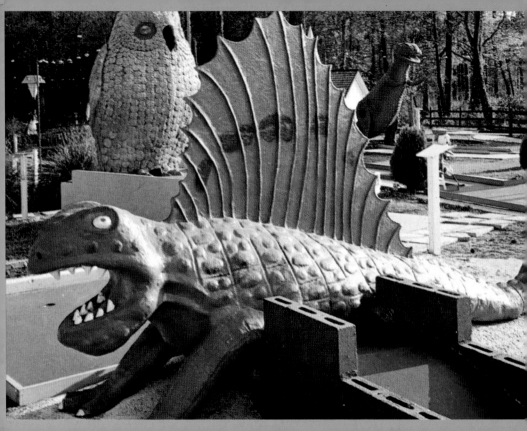

THE MINIBOOK OF MINIGOLF

Tim Hollis

Seaside Publishing

Gainesville · Tallahassee · Tampa · Boca Raton

Pensacola · Orlando · Miami · Jacksonville · Ft. Myers · Sarasota

Page i: Probably no miniature golf course in the Southeast is more legendary than Panama City Beach's Goofy Golf. Its colorful, oversized obstacles have been attracting beachgoers since 1959.

Page ii: Dinosaurs and other beasts of yesterday lumbered onto minature golf courses in the 1950s, leaving their pre-historic tracks from the mountains to the beach and everywhere in between.

For information about permission to reproduce selections from this book, write to Permissions, 15 Northwest 15th Street, Gainesville, FL, 32611-2079.
Printed in Korea on acid-free paper

20 19 18 17 16 15 6 5 4 3 2 1

Library of Congress Control Number: 2014949010
ISBN 978-0-942084-94-8

SEASIDE PUBLISHING

Seaside Publishing is a division of the University Press of Florida.

For a complete list of Seaside books, please contact us:
Seaside Publishing
15 Northwest 15th Street
Gainesville, FL 32611-2079
1-352-392-6867
1-800-226-3822
orders@upf.com
www.seasidepublishing.com

Thanks

Much of the material in this book came from the author's personal collection of photos and memorabilia. Additional photos and information were contributed by Ace Neon Co.; Wayne Aiken; Karen Baker and Sara Gard of See Rock City, Inc.; Jerry Beck; Joseph Burcham; Becky Craddock; Cariss Dooley; Jim Hatcher; Rick Kilby; Randy Koplin; Dutch Magrath; Donnie Pitchford; Adrienne Rhodes, Talley Green and George Murray of Lake Winnepesaukah Park; Brian Rucker; Debra Jane Seltzer; Gareth Stearns; and Russell Wells.

Here is your author on his very first visit to a miniature golf course, June 1970. By the way, the author is the one wearing sunglasses.

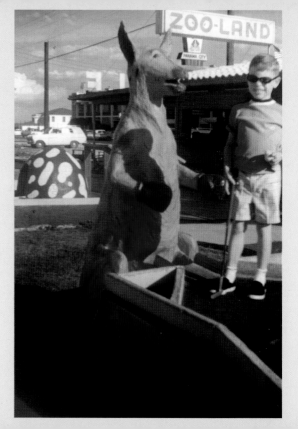

Introduction

Miniature golf has become such a familiar part of American pop culture that it sometimes seems everyone must have been exposed to the pastime in one form or another. As we are about to see in the pages that follow, this basically simple game has more varieties than any other sport. That is, assuming we consider it a sport at all—miniature golf has been called "the feeblest outdoor activity outside of waiting for a bus," but we shall simply ignore such wisecracks.

Although minigolf has a ready audience throughout the United States and has even enjoyed great popularity overseas, it only makes sense to begin an examination of its history where it debuted in the southeastern quarter of the country. Though practice putting greens had been in use for many years and though several concepts foreshadowed miniature golf, it is generally conceded that in 1925 hotel owner Garnet Carter of Chattanooga, Tennessee, developed the game as we know it. At his Fairyland Inn atop Lookout Mountain, Carter

and his wife Frieda introduced Tom Thumb Golf, a course which broke with the notion of being merely a substitute for "real" golf. Instead, the Carters created a completely new diversion. Going along with the name and the miniature theme, tiny obstacles were placed among the fairways to make things more challenging.

The familiar playing surface covered in carpet or artificial turf came later. Such things were either too expensive or had not been invented yet, so the first miniature golf courses were surfaced with crushed cottonseed hulls, frequently dyed green. Regardless, miniature golf became a national fad during the early years of the Great Depression, when people were starving not only for food but for any type of amusement that cost very little.

Like most crazes, the initial fascination with miniature golf had burned itself out within a couple of years and became more or less a joke to those who had seen it. Unexpectedly, the decade following World War II saw a rebirth of miniature golf, not as a fad but as a part of the booming tourism landscape. In the pages that follow, we will see all types of courses, from simple hometown affairs to showy tourist attractions complete with giant concrete dinosaurs. So pick up your club and ball, and step this way, to Hole Number One!

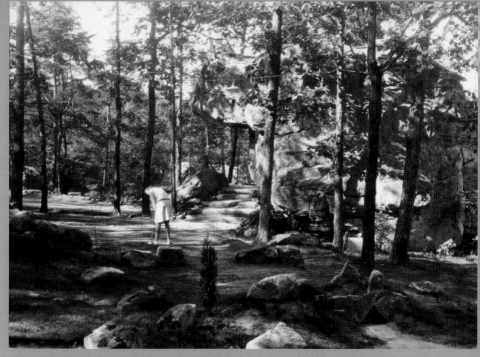

The original Tom Thumb Golf on Lookout Mountain, near Chattanooga, did not much resemble today's miniature golf courses, but took advantage of the natural terrain and abundance of boulders.

1

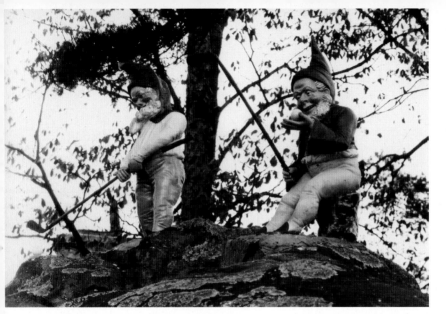

One of the innovations at the Tom Thumb Golf courses was the addition of gnome statues at various points, lending visual interest and whimsy to the already novel pastime.

→ Garnet Carter felt that if visitors to his hotel found Tom Thumb Golf so entertaining, people elsewhere would enjoy it too. He patented his idea and began selling franchises, which were promoted in ads such as this one from the May 3, 1930, *Saturday Evening Post*.

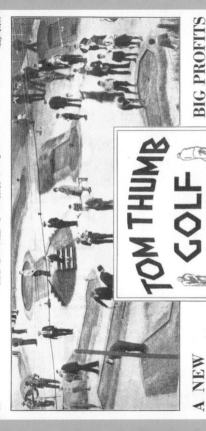

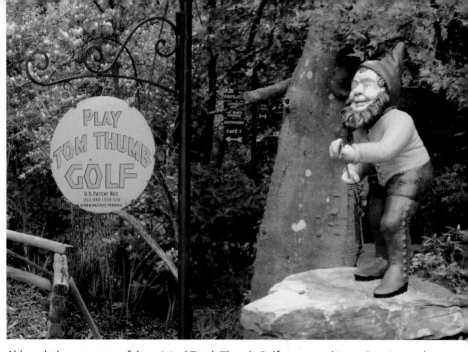

Although the remnants of the original Tomb Thumb Golf were razed in 1958, a sign and one of the original gnomes remain on display at Garnet Carter's more famous tourist attraction atop Lookout Mountain, Rock City Gardens.

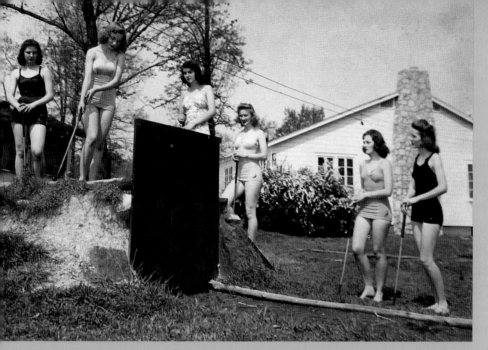

The miniature golf course at Georgia's Lake Winnepesaukah opened in the summer of 1930. Even though the original craze for miniature golf was over by the next year, "Lake Winnie's" survived to become the longest continuously operating minigolf in the world. These bathing beauties show it going strong during World War II.

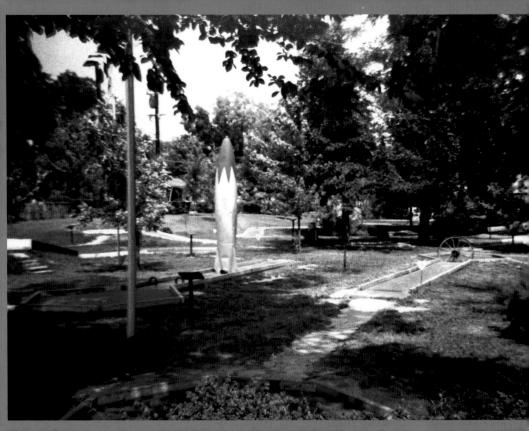

← There have been very few changes in the Lake Winnepesaukah course since 1930, mainly the addition of new obstacles from time to time and the eventual use of carpet instead of the original cottonseed hull playing surfaces.

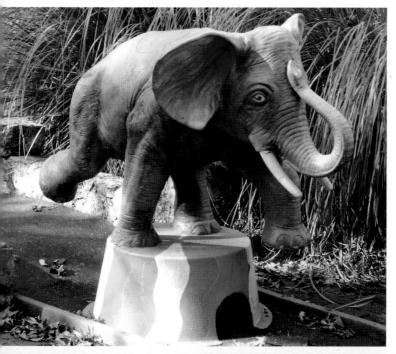

The Lake Winnepesaukah course has managed to retain its old-fashioned charm for new generations. This elephant does not date back to 1930, but it has held its ground for the better part of forty years.

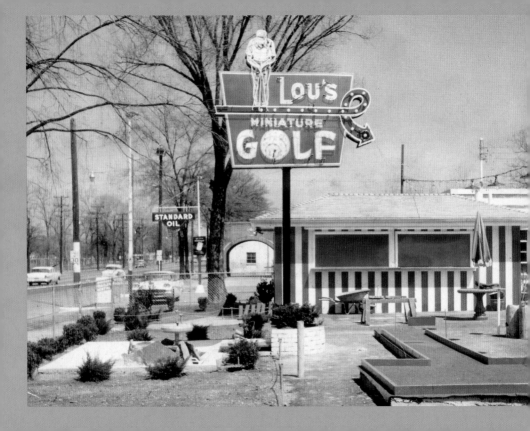

With the simultaneous explosion of the baby boom and the growth of the suburbs, miniature golf was reborn in the 1950s. The new courses often featured flashy signage that was sometimes more impressive than the game.

There were, are, and seemingly always will be basic, unadorned miniature golf courses serving their loyal customers in small towns and out-of-the-way locations, quite unperturbed by the more elaborate courses found in high-traffic resorts.

Hearkening back to the original Tom Thumb concept, even today there are courses that survive and thrive with the simplest obstacles imaginable.

← This peaceful postcard scene at Kentucky's Beech Bend Park shows that minigolf does not have to feature lush landscaping and special effects to be appealing.

The growth of the tourism industry in the post-World War II world brought about more and more courses with themes tied to their specific areas. What better fit could there be than Hillbilly Golf in Gatlinburg, Tennessee?

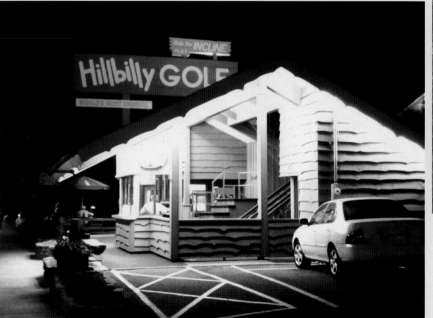

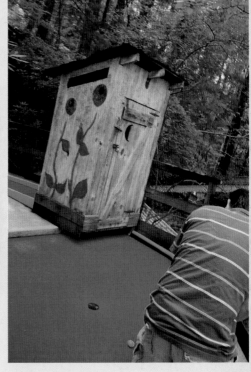

Although the residents of the Great Smoky Mountains have justifiable misgivings about the trappings of the "hillbilly" image, they have been perfectly willing to embrace such emblems for the sake of separating tourists from their money. Hillbilly Golf has been cackling all the way to the bank since 1971.

13

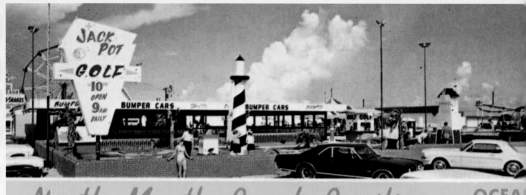

North Myrtle Beach Pavilion AT OCEAN DRIVE

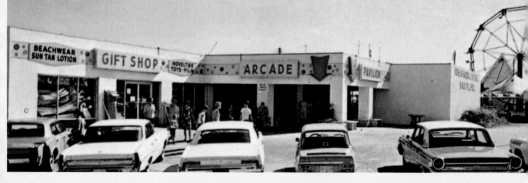

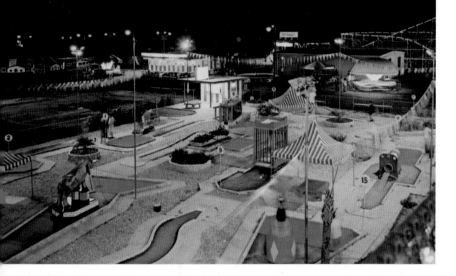

Greetings From
North Myrtle Beach Amusement Park

Because of the climate and because water draws seasonal vacation crowds, waterside, especially ocean beach, resorts have always been particularly welcoming to the miniature golf concept. Myrtle Beach is recognized as having the greatest concentration of courses in the country. These were two of the early ones, and they would be joined (and eventually replaced entirely) by dozens more in years to come.

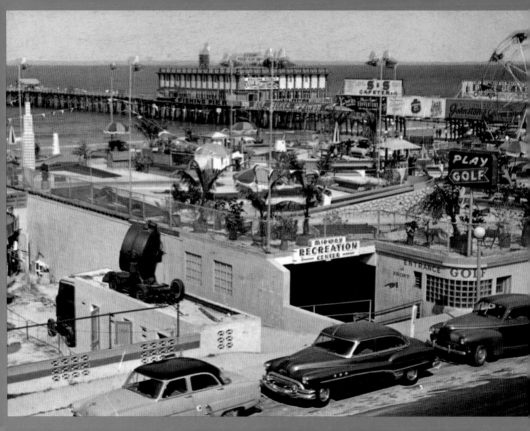

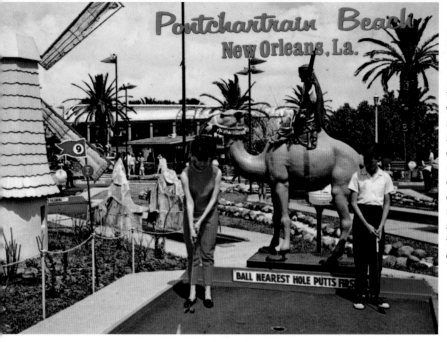

BALL NEAREST HOLE PUTTS FIRST

Lakeside Pontchartrain Beach, near New Orleans, featured along with its other amusements at least one elaborate miniature golf course, where each hole represented a different foreign country.

← The boardwalk at Daytona Beach was another great spot to observe the growth of seaside minigolf courses. Some, such as this colorful course at the Midway Recreation Center, were built on the roofs of buildings rather than at ground level.

Union Chapel Golf Course Proudly Announces...

LOMMA CHAMPIONSHIP
MINIATURE GOLF COURSE

Putters & Balls Furnished At NO EXTRA COST!

18 Hole Round Plus a FREE 19th Hole!

Only **75¢** Per Game

OPEN NIGHTLY 7 NIGHTS A WEEK!

LOCATED ADJOINING CLUB HOUSE AT THE UNION CHAPEL GOLF COURSE 2 7/10 miles East of Whiteway Restaurant Turn Left on Boldo Cut-Off Road and 7/10 Mile to Club House.

Each Hole is different and is designed for pleasure of putting at every turn. A challenge for pros and beginners to improve your putting.

CHURCH & CLUB GROUPS will be given Discount Rates anytime!

Enjoy the Newest Game in Golf at
Union Chapel Golf Course

Elbert Daniel & Sons Owners Phone 483-6656

18

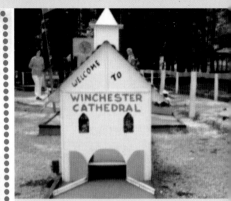

Brothers Al and Ralph Lomma went into the business of manufacturing mechanized minigolf obstacles in the mid-1950s. A Lomma course was easy to identify because the same miniature buildings could be found from coast to coast.

→ The Ambassador Motel in Cave City, Kentucky, gave its patrons something to do by providing an adjoining Lomma-style minigolf course.

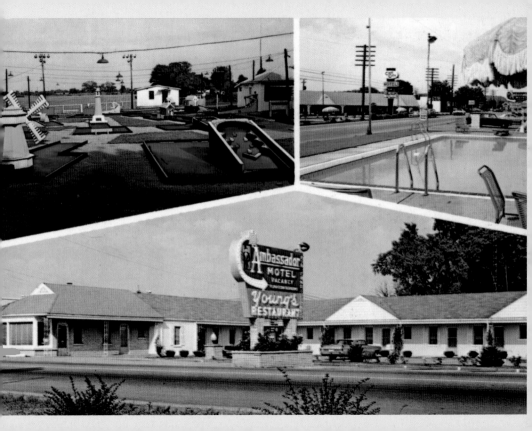

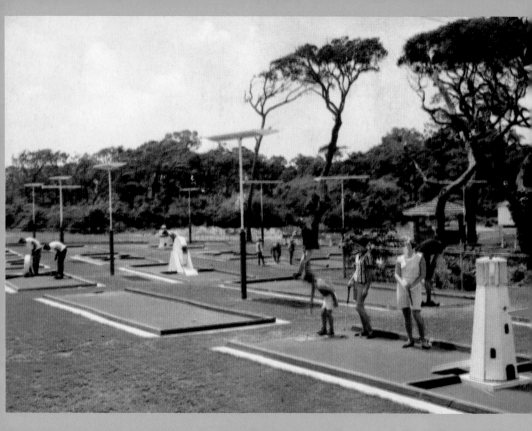

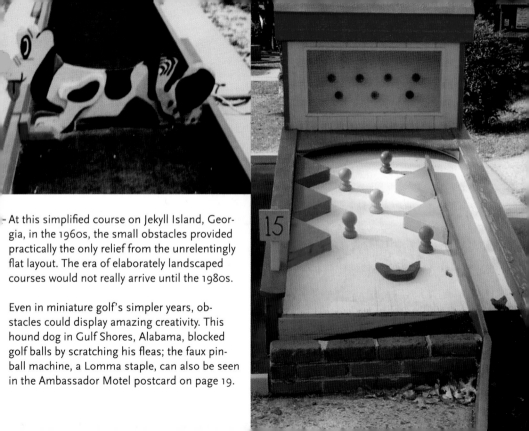

At this simplified course on Jekyll Island, Georgia, in the 1960s, the small obstacles provided practically the only relief from the unrelentingly flat layout. The era of elaborately landscaped courses would not really arrive until the 1980s.

Even in miniature golf's simpler years, obstacles could display amazing creativity. This hound dog in Gulf Shores, Alabama, blocked golf balls by scratching his fleas; the faux pinball machine, a Lomma staple, can also be seen in the Ambassador Motel postcard on page 19.

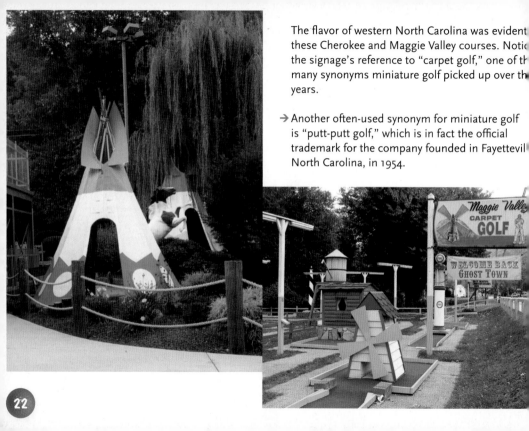

The flavor of western North Carolina was evident [in] these Cherokee and Maggie Valley courses. Notic[e] the signage's reference to "carpet golf," one of th[e] many synonyms miniature golf picked up over th[e] years.

→ Another often-used synonym for miniature golf is "putt-putt golf," which is in fact the official trademark for the company founded in Fayettevil[le] North Carolina, in 1954.

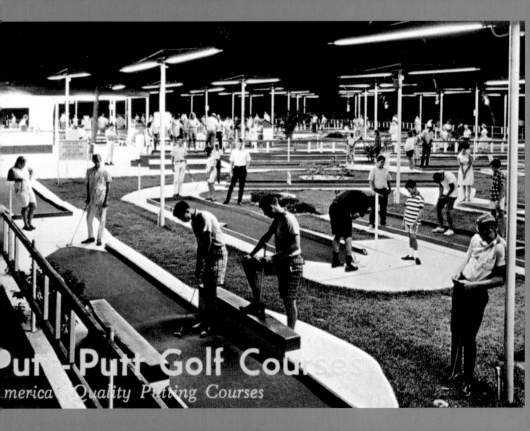

Putt-Putt® Golf Courses

merica's Quality Putting Courses

Putt-Putt Golf founder Don Clayton was not a fan of the gimmicky obstacles that were beginning to dominate the sport, but some of the early courses in the chain featured them anyway, including this example in Birmingham, Alabama.

→ The typical Putt-Putt Golf was dignified and tasteful, with an eye-catching and unmistakable orange and green color scheme.

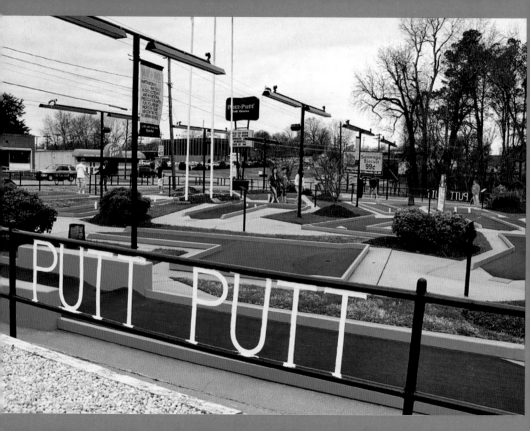

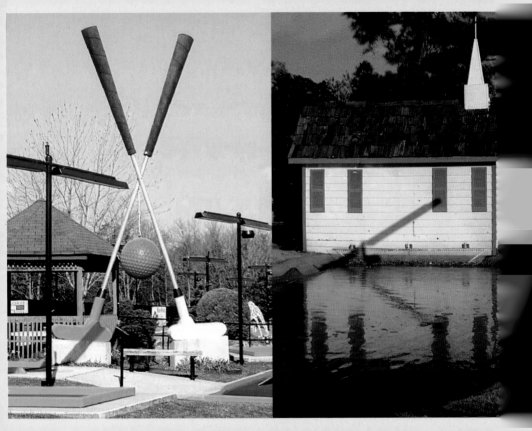

← While a few of the original Putt-Putt Golf courses remain unchanged, many more have decided to spice up their sterile appearances with fiberglass statues and other decorations.

Another popular minigolf chain, especially during the 1970s, licensed golf pro and course designer Arnold Palmer's name for identification. Like the Lomma style, every Arnold Palmer Putting Course contained the same obstacles.

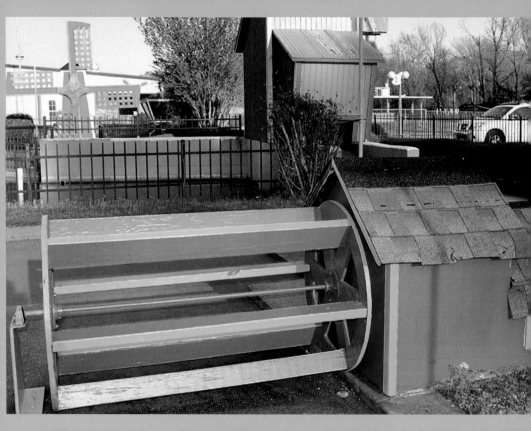

Because they were all identical, it is easy to recognize what used to be an Arnold Palmer course, even when the obstacles have been repainted in shocking colors good old Arnold probably never dreamed of.

Each location in the chain of Yogi Bear's Jellystone Park Campgrounds had its own miniature golf course, but their styles ranged from elaborate to extremely downplayed. At some of them, players could win a free game by landing their ball in Yogi's hollow nose.

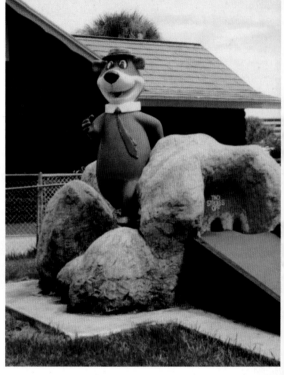

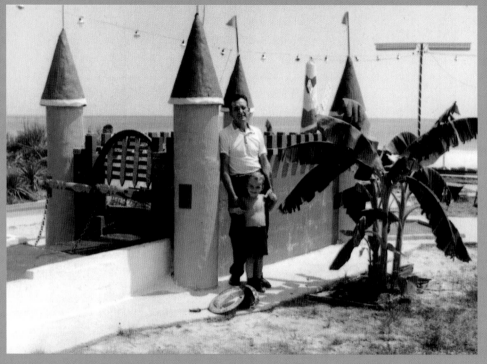

In 1958, Lee Koplin (seen here with son Randy) built his original Goofy Golf course on the beach at Biloxi, Mississippi. Before long, the "Goofy Golf" name would be yet another (unauthorized) synonym for miniature golf.

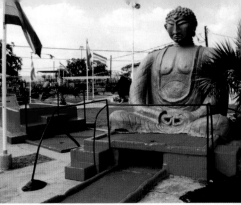

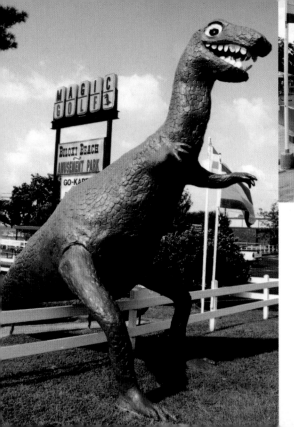

After being sold, the original Biloxi Goofy Golf became known as Magic Golf. It survived until 2005, when, like most of Mississippi's Gulf Coast, it was obliterated by Hurricane Katrina. Lee Koplin's second Goofy Golf in Biloxi was wiped out not by a hurricane, but by the explosion of the hotel and casino industry in the region. Its former site is now a hotel parking lot.

Although the Koplins did not own the next Goofy Golf course in Pensacola, Florida, the family holds that Lee did participate in its construction. It too opened in 1958. The giant sea monster in front of the main building became a landmark on Pensacola's busy Navy Boulevard.

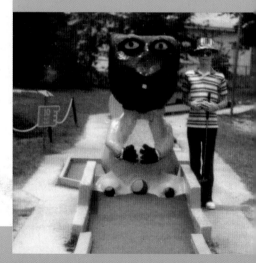

OFFICIAL

GOOFY GOLF

FUN FOR ALL!

OPEN
9 AM-12 PM DAILY

3920 NAVY BOULEVARD

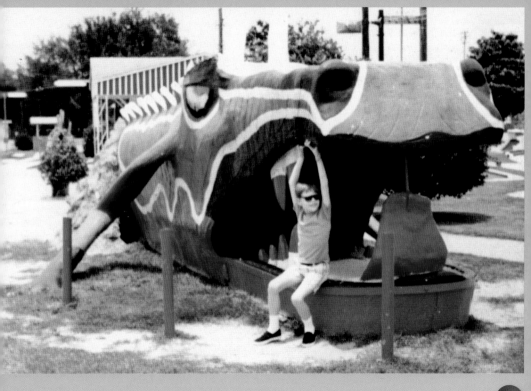

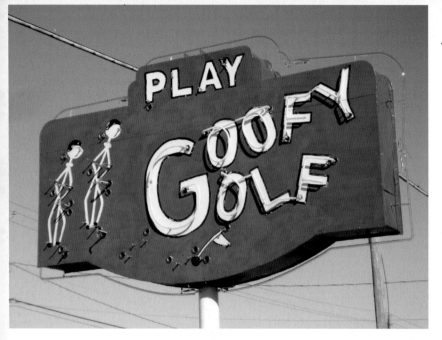

→ A few years after opening, Fort Walton Beach's Goofy Golf gained this eye-catching road-side lure, a giant tyrannosaurus that somehow received the nickname "Hammy."

The Goofy Golf in Fort Walton Beach, Florida, was built by J. W. Hayes and opened in August 1959. To this day it remains one of the most lovingly maintained vintage courses in the country, even keeping its original neon sign.

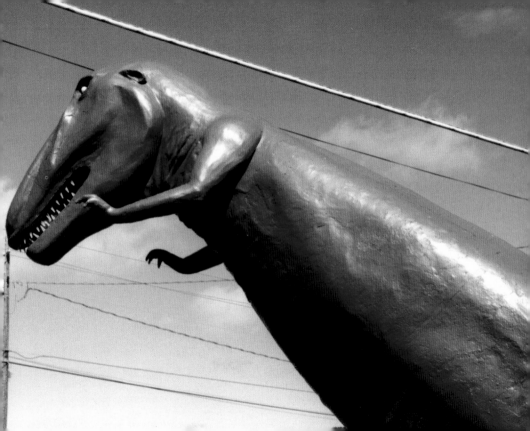

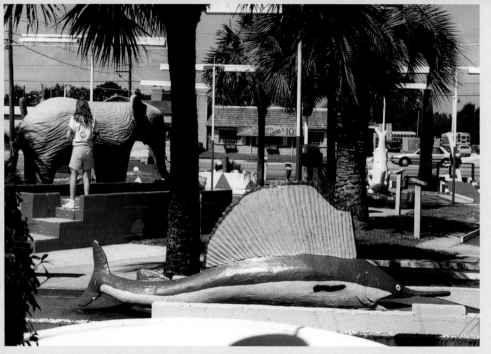

Since sailfish are among the most common figures in Florida souvenirs, it is natural that one was hooked into Fort Walton Beach's Goofy Golf. Other beasts still roaming the property after more than fifty years include an elephant, a kangaroo, and a gorilla with a deadpan stare.

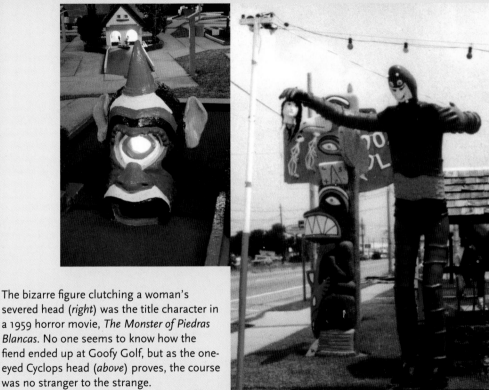

The bizarre figure clutching a woman's severed head (*right*) was the title character in a 1959 horror movie, *The Monster of Piedras Blancas*. No one seems to know how the fiend ended up at Goofy Golf, but as the one-eyed Cyclops head (*above*) proves, the course was no stranger to the strange.

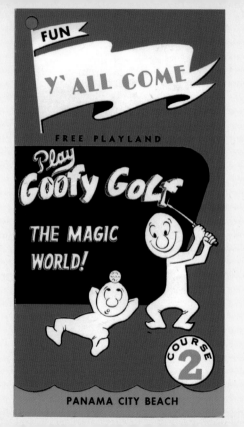

FUN

Y' ALL COME

FREE PLAYLAND

Play
Goofy Golf

THE MAGIC
WORLD!

COURSE
2

PANAMA CITY BEACH

Lee Koplin's previous Goofy Golfs appeared to be merely the rehearsals for the massive course at Panama City Beach, Florida. The Koplin family's story is that Lee was troubled by nightmares in which he was chased by frightening monsters—perhaps the one from Piedras Blancas was among them?—and he was inspired to tame his nocturnal fears by turning the creatures into giant-sized obstacles in his new course. This was the ultimate break from miniature golf's original concept, where the fairways and obstacles were tiny and players towered over them.

→ This view of Goofy Golf was made from across the street in 1960, its second year of operation. Had it not been for the oversized, colorful signage, those who gave the property only a casual glance might not have recognized it as a miniature golf course at all.

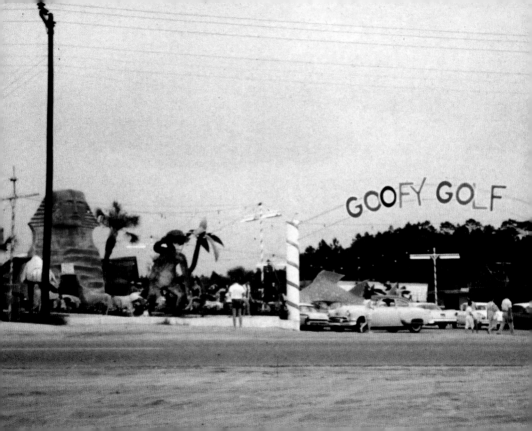

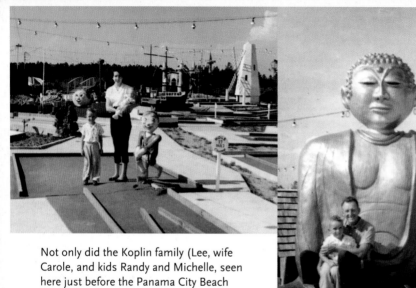

Not only did the Koplin family (Lee, wife Carole, and kids Randy and Michelle, seen here just before the Panama City Beach course opened in the spring of 1959) build and maintain Goofy Golf, they also lived in a house in the middle of the course. Not many youngsters can claim that Goofy Golf was quite literally their yard.

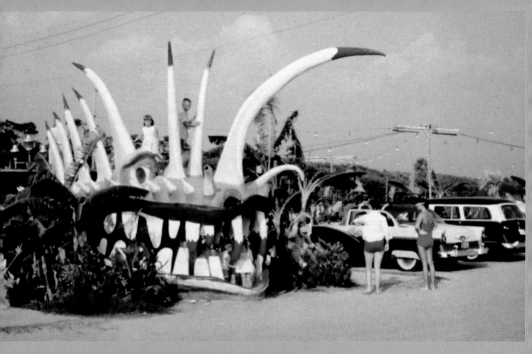

Panama City Beach's sea monster, whose gaping mouth was actually a tunnel to the ticket window, may well have been a direct descendant of the one at the Pensacola Goofy Golf we saw on page 33.

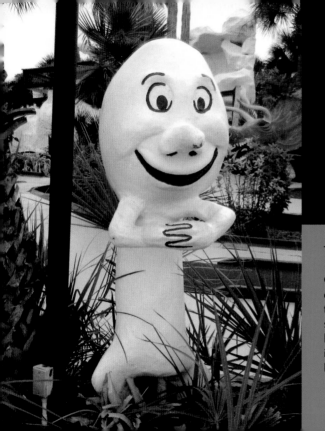

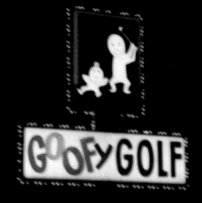

The origin of Goofy Golf's trademark (page 38), a ghostly figure known as Mr. Goofy knocking a golf ball off his shorter companion's head, is a mystery to even the Koplin family. Mr. Goofy can still be seen in statue form next to the parking lot; the 1970s sign in this nighttime shot is no longer there, but the twin Goofies live on as part of the scorecards.

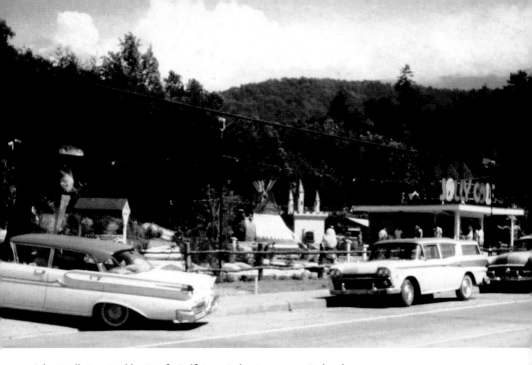

Admittedly inspired by Goofy Golf, in 1961 businessmen Richard Craddock and Jim Sidwell built their own version, Jolly Golf, in one of the south's other emerging tourism capitals, Gatlinburg, Tennessee.

43

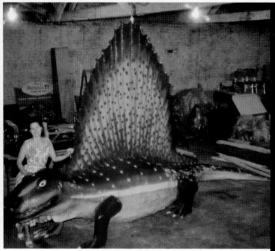

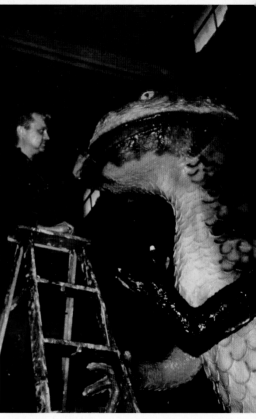

Jim Sidwell crafted the Jolly Golf figures in the warehouse of his furniture store in Murfreesboro—notice the discarded Motorola TV sign in the background (*above*). He soon had a very profitable business creating dinosaurs and other statues for tourist attractions and amusement parks in addition to many more miniature golf courses.

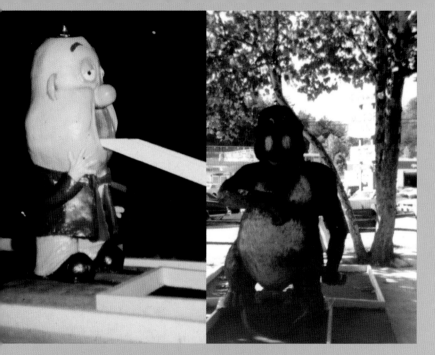

There is something disturbing about the route taken by the golf ball through this 1961 Jolly Golf figure resembling Elmer Fudd (*left*). However, the gorilla that later replaced Elmer (*right*) had his own uncomfortable anatomical aspects too.

→ By the time of this 1970s shot, Jolly's landscaping had filled in, and Jim Sidwell's boundless imagination had produced a number of figures that were not part of the original design.

The photos on this and the next page give an intriguing look at Jolly Golf's evolution. In this view from 1961, the course still looks a bit "flat" and unadorned.

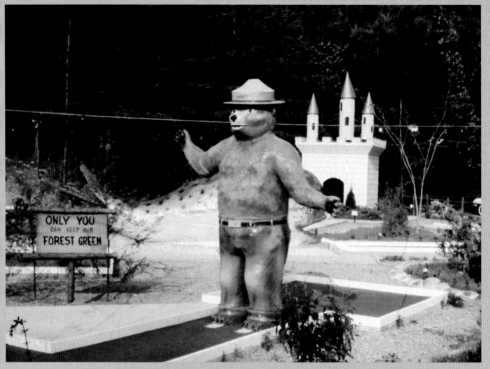

One of Jolly Golf's most prized figures in its earliest days was this version of Smokey Bear, with a right arm that moved back and forth in a friendly wave.

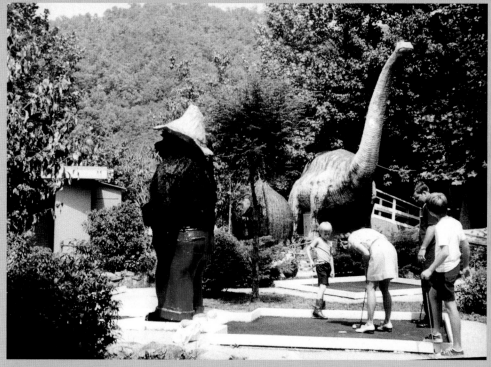

Most likely because the U.S. Forest Service had something to say about an unlicensed use of their trademark, by the 1970s Smokey Bear had received a new skin and hillbilly hat to become Old Pokey Bear.

In the 1990s, the Sidwell family revamped Jolly Golf into Dinosaur Golf, removing any previous non-prehistoric figures and bringing in a few new saurian citizens.

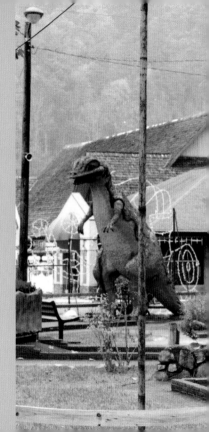

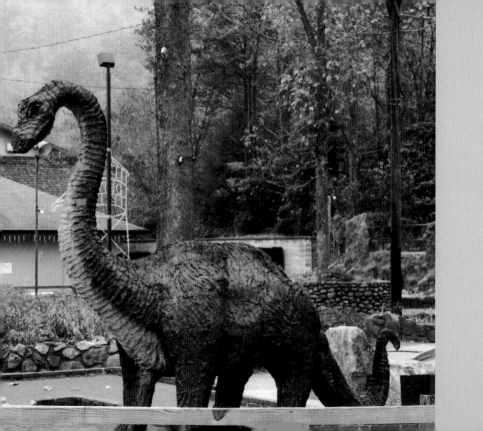

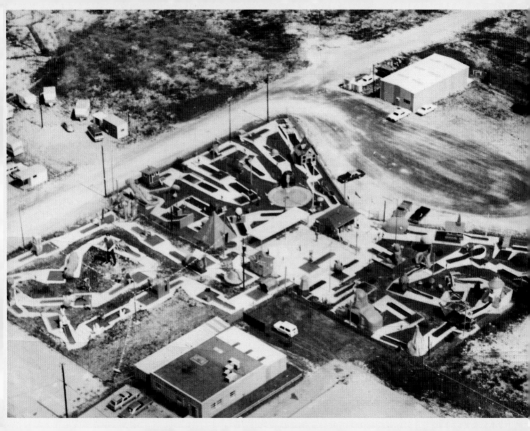

← Another course that took its cue from Goofy Golf was Sir Goony Golf, the first of which was built by Dutch Magrath in the eastern suburbs of Chattanooga in 1962. As this aerial view indicates, Sir Goony's original layout was enormous.

Within a few years, Dutch Magrath was franchising Sir Goony Golf throughout the United States. In 1978, the original course was moved a block south of the first location. The photo below was taken while the big migration was still under way.

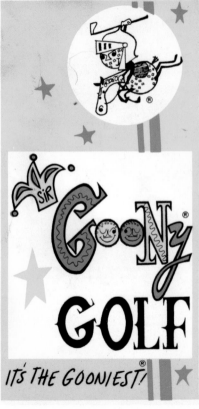

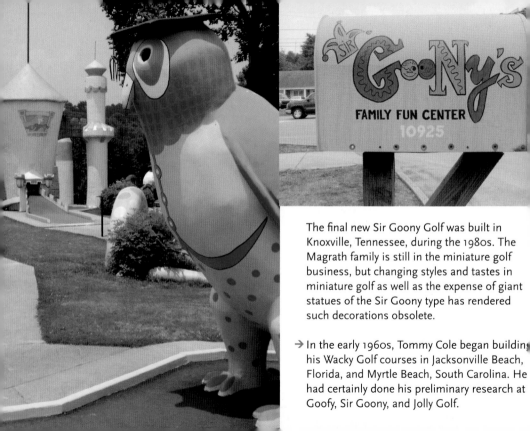

The final new Sir Goony Golf was built in Knoxville, Tennessee, during the 1980s. The Magrath family is still in the miniature golf business, but changing styles and tastes in miniature golf as well as the expense of giant statues of the Sir Goony type has rendered such decorations obsolete.

→ In the early 1960s, Tommy Cole began building his Wacky Golf courses in Jacksonville Beach, Florida, and Myrtle Beach, South Carolina. He had certainly done his preliminary research at Goofy, Sir Goony, and Jolly Golf.

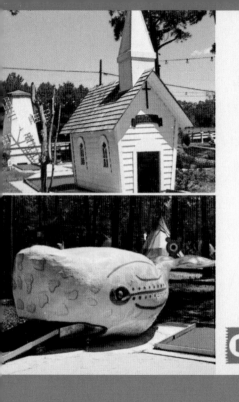
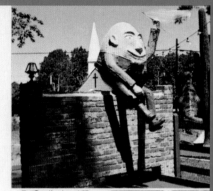
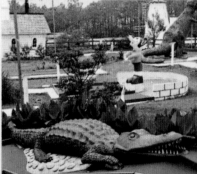

Wacky

GOLF

One celebrity who turned up over and over again as a special guest star at minigolf courses was that brittle nursery rhyme superstar Humpty Dumpty. Here he is, doing his balancing act at Jolly Golf in 1961.

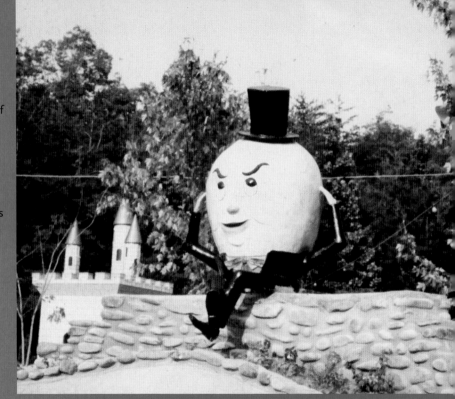

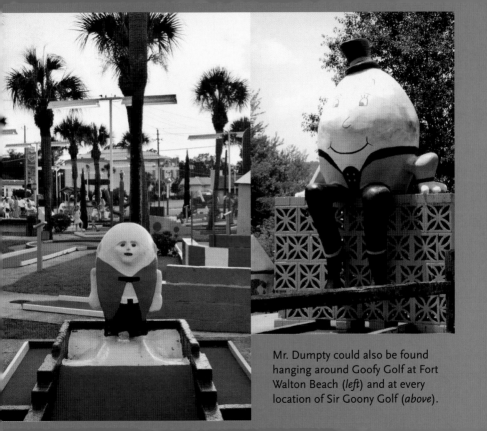

Mr. Dumpty could also be found hanging around Goofy Golf at Fort Walton Beach (*left*) and at every location of Sir Goony Golf (*above*).

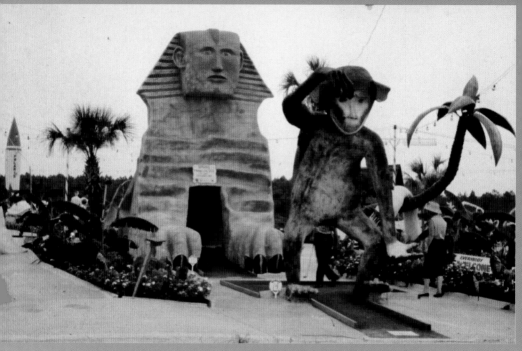

Without a doubt, the most photographed sight at Panama City Beach's Goofy Golf was the giant monkey with the stoic Sphinx looming behind. The monkey would soon clutch the top of a palm tree in his right hand, but in this pre-palm tree 1960 photo his pose just looks a bit awkward.

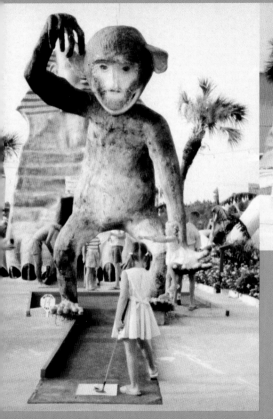
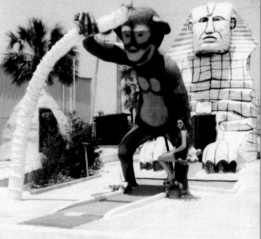

Several generations of youngsters have maintained the tradition of having their photos taken in the monkey's lowered left hand, throughout many varying paint jobs and color schemes.

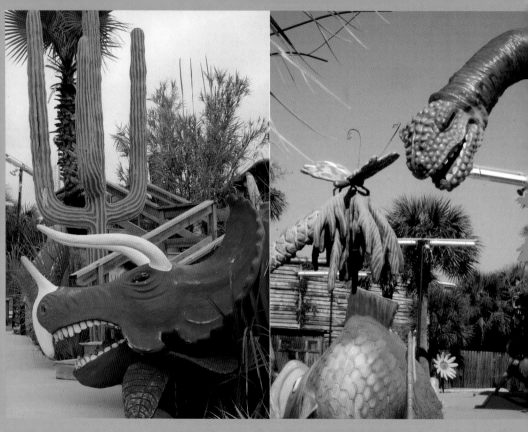

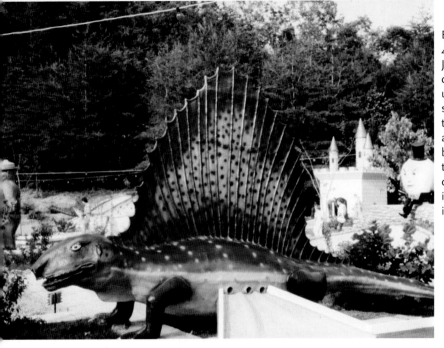

Back on page 44, we saw Jolly Golf's dimetrodon under construction in the warehouse at Murfreesboro. Here is the sailbacked dinosaur after its installation in Gatlinburg.

← Lee Koplin usually receives credit for introducing dinosaurs into the world of miniature golf. His timing was perfect, as baby boomers displayed an unparalleled fascination with the prehistoric beasts.

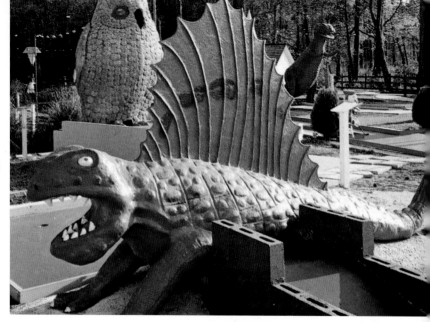

Tommy Cole once owned a sporting goods store in Murfreesboro, where Jolly Golf's Jim Sidwell was building dinosaurs in his warehouse, and it seems he might have picked up a few pointers he was able to use at his Wacky Golf courses in South Carolina and Florida.

→ A religious icon is not what one might expect to find as a miniature golf obstacle, but the Goofy Golf courses (page 40), Sir Goony Golf (*left*), and Fantasia Golf in Tampa, Florida (*right*) all found inner peace the same way—although in wildly varying proportions and color schemes.

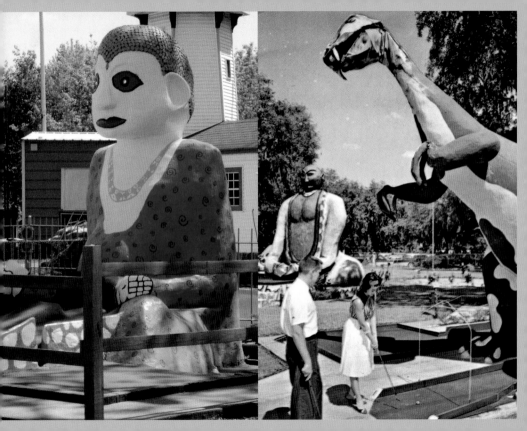

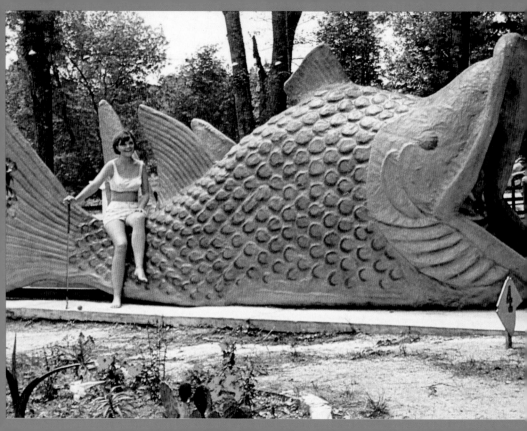

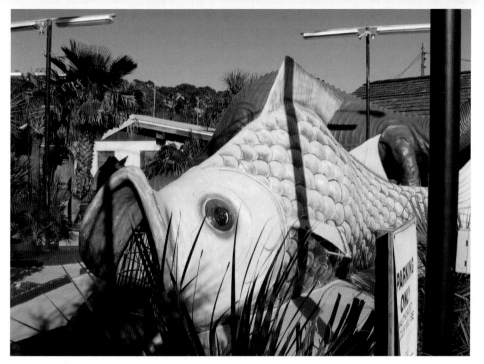

People usually, and with good reason, doubt stories about "the one that got away." Both Wacky Golf (*left*) and Goofy Golf (*above*) provided an opportunity for comic photo opportunities for frustrated anglers.

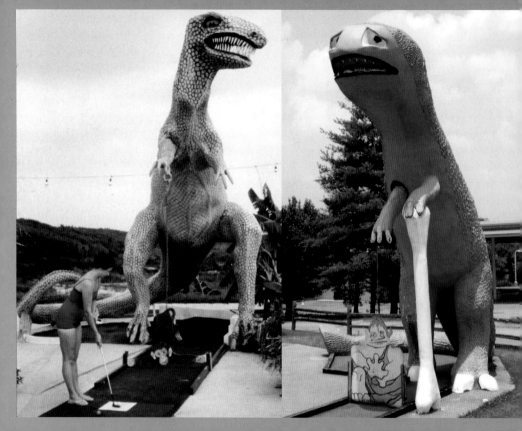

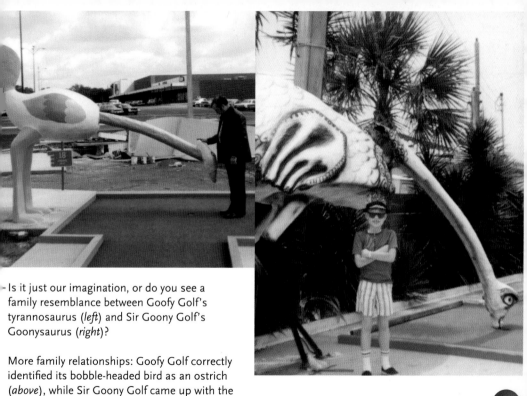

Is it just our imagination, or do you see a family resemblance between Goofy Golf's tyrannosaurus (*left*) and Sir Goony Golf's Goonysaurus (*right*)?

More family relationships: Goofy Golf correctly identified its bobble-headed bird as an ostrich (*above*), while Sir Goony Golf came up with the less scientific name Goonybird (*right*).

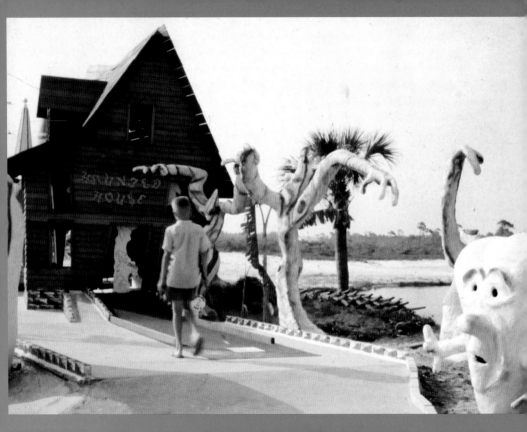

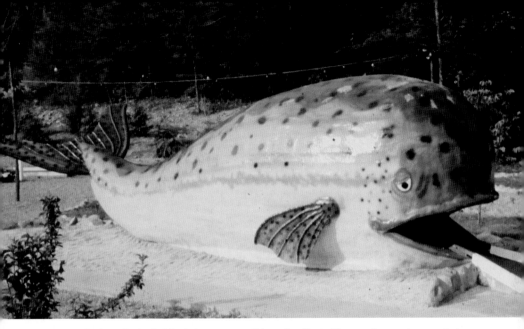

← Take a close look at the befuddled ghosts making "specters" of themselves around Goofy Golf's haunted house; you are going to see one of their creepy cousins turn up a bit later.

Although Jolly Golf sat in the tourism capital of the Great Smoky Mountains, its heritage from courses found at the beach was sometimes obvious. This was perhaps the only whale to be found swimming through the Smokies' wooded hillsides.

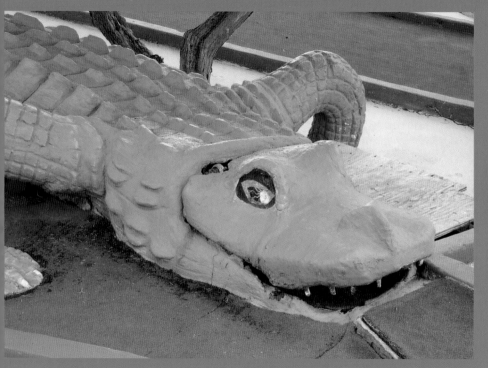

The alligator at Goofy Golf has been opening and closing his concrete jaws and swallowing golf balls for well over five decades, and he's still hungry.

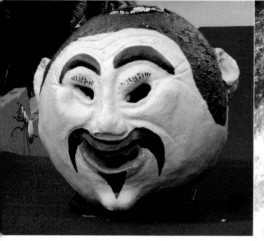

It often seemed Panama City Beach's Goofy Golf was bent on living up to its name. Not only were players routed through an impressive concrete cave at one point, but the "Chinese Ant Hill" obstacle has so far survived all bouts with political correctness.

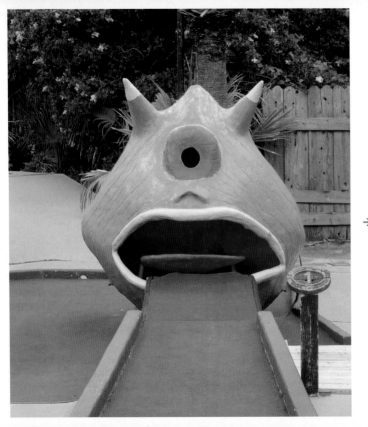

The way pop culture repeats itself can be amusing. Goofy Golf's monocular creature known as the Goop has existed since 1959, but children of the 21st century invariably mistake it for Mike Wazowski of Disney/Pixar's *Monsters, Inc.* movies.

→ In an extremely unusual turn of events, in the late 1970s the Goofy Golf at Pensacola was purchased by Sir Goony Golf but retained its name. Original 1958 obstacles—such as the giant shoe in the center of this photo—were joined by Sir Goony's usual characters.

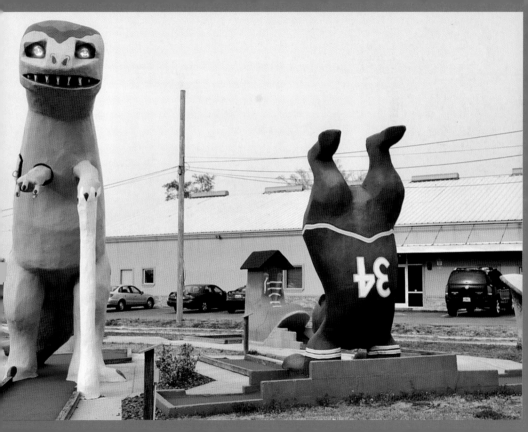

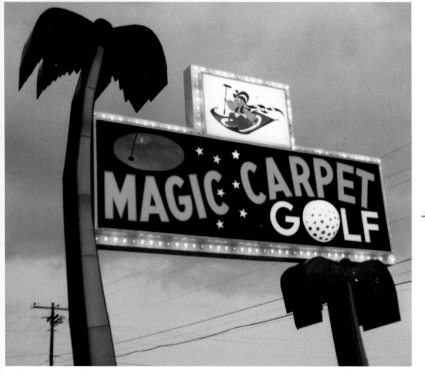

We mentioned earlier that "goofy golf" became an unauthorized synonym for miniature golf. For that reason, latter-day Koplin family courses adopted the trademarked name Magic Carpet Golf.

→ Magic Carpet Golf was (and still is) especially popular in the western United States, but there were several popular Florida locations including Key West and Fort Walton Beach (pictured here).

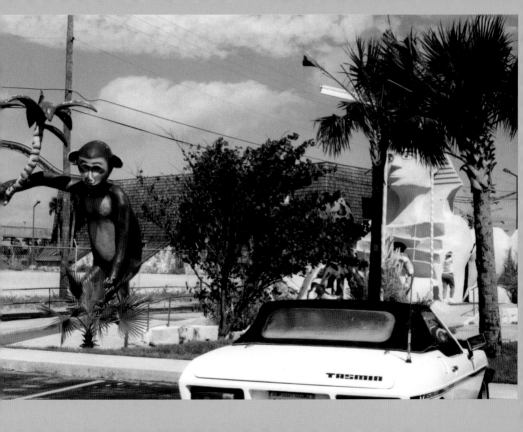

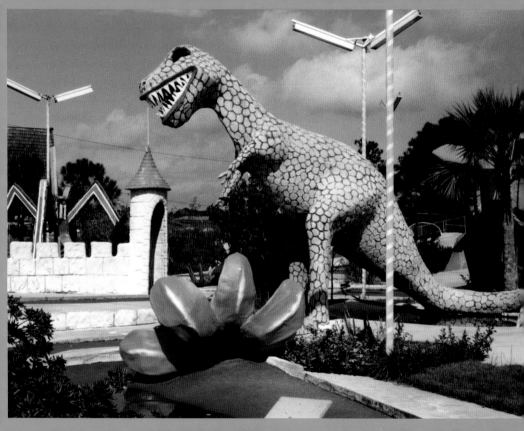

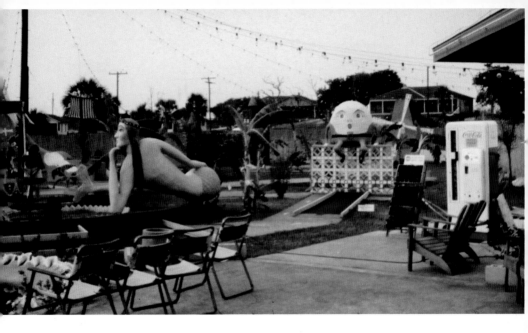

← Most of the familiar figures from Goofy Golf could be found duplicated at Magic Carpet Golf, including our old buddy the tyrannosaurus.

Well, look who's here. It's our favorite egghead Humpty Dumpty again, this time at a small, unnamed course at Florida's Long Beach Resort. That giant mermaid looks a bit formidable, don't you think?

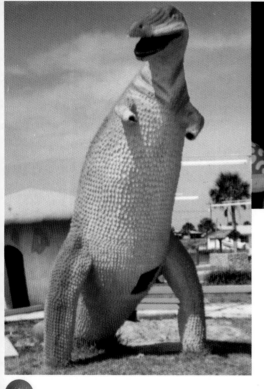

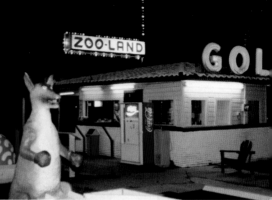

In 1960, retired sign painter L. L. Sowell built Zoo-Land Golf at the far western limits of Panama City Beach. His pride and joy was the roadside dinosaur that breathed fire from its mouth via a concealed gas pipe.

→ When Zoo-Land Golf first opened, very little commercial development surrounded it. That has since changed: the property is now home to a giant condo, and no traces of Zoo-Land's existence can be seen.

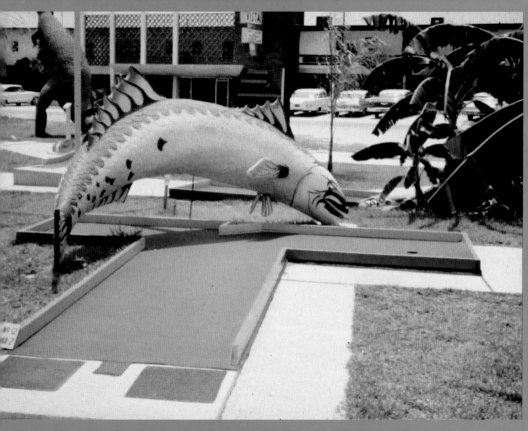

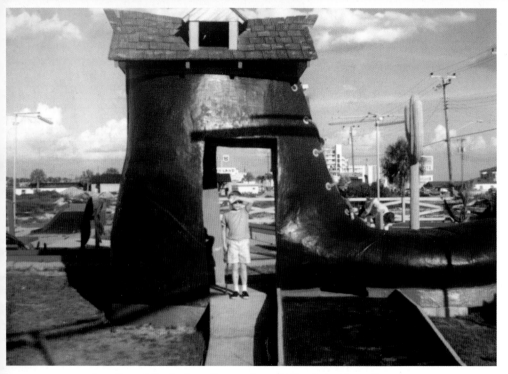

Sowell used illustrations from various children's books as the models for his Zoo-Land Golf statuary, such as this giant shoe from Mother Goose and the candy house from *Hansel and Gretel*.

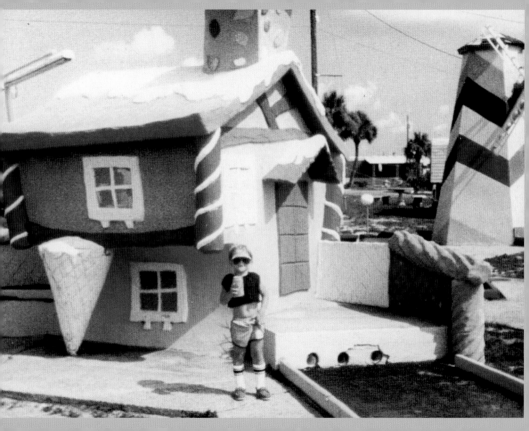

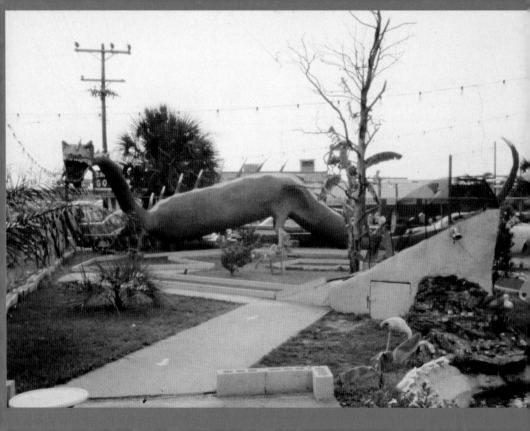

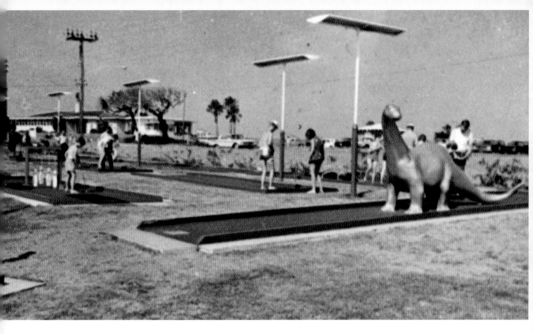

← You've heard the statement that a camel is a horse that was designed by a committee? Well, Long Beach's dragon looked like it was designed by a committee of camels—or something like that.

Down on Georgia's Jekyll Island, this small course operated in the 1960s with a dinosaur formerly employed by a Sinclair service station as its focal point.

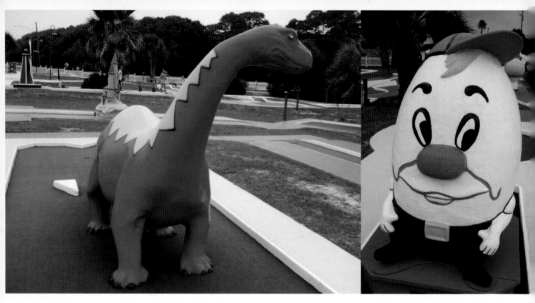

It is not certain whether this present-day Jekyll Island dinosaur is the same one from the 1960s view, but there are some new characters: that Humpty Dumpty guy sure does know how to get around.

→ These gloriously creepy homemade figures could be seen in Gulf Shores, Alabama. The course they inhabited was known at various times as Spooky Golf and Surfside Golf. Under either name, it did not survive Hurricane Frederic in 1979.

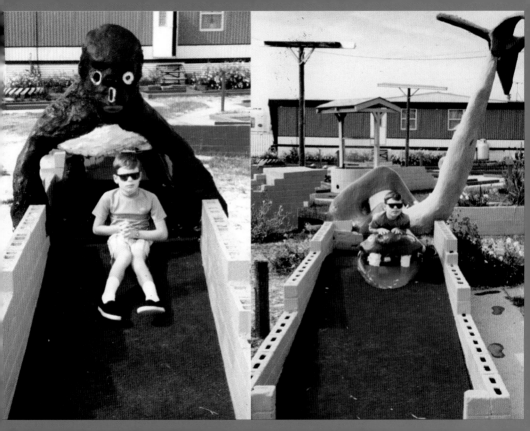

The original Goofy Golf was not the only one of its ilk in Biloxi, Mississippi. Fun Time Golf sat nearby with its own collection of oddball characters.

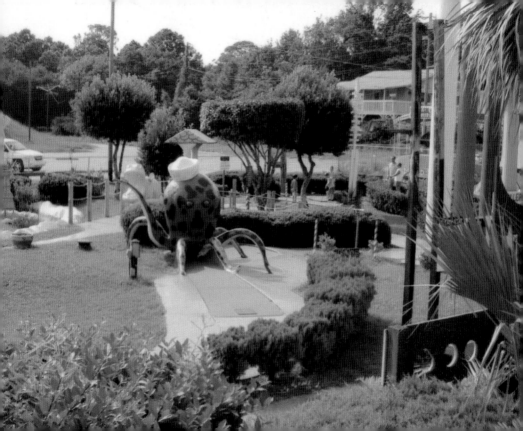

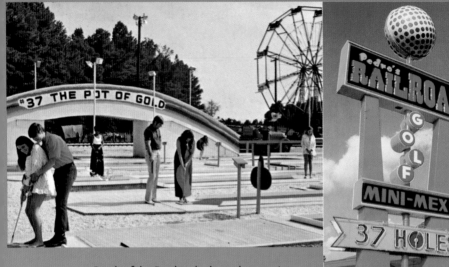

South of the Border, the legendary tourist complex on the North/South Carolina line, had practically every imaginable amusement for those traveling to or from Florida, so it should have been expected that miniature golf would be one.

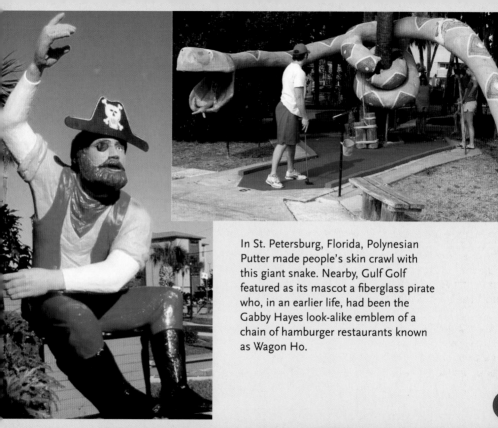

In St. Petersburg, Florida, Polynesian Putter made people's skin crawl with this giant snake. Nearby, Gulf Golf featured as its mascot a fiberglass pirate who, in an earlier life, had been the Gabby Hayes look-alike emblem of a chain of hamburger restaurants known as Wagon Ho.

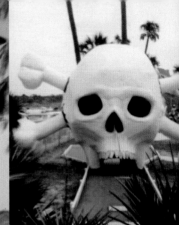

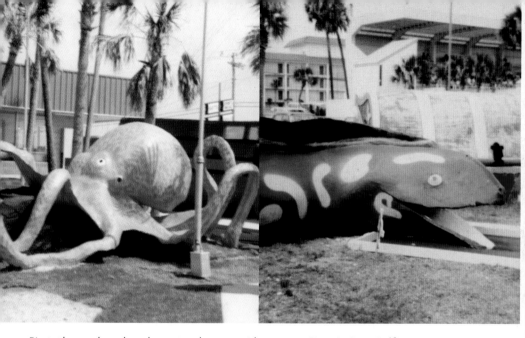

Pirate themes have long been popular at seaside courses. Pirate's Cove Golf at Panama City Beach had everything from a skull and crossbones and genuine crow's nest—complete with crow—to a walk-in replica of Moby Dick and other sea creatures. The site is now the parking lot behind a diner, adjacent to the veteran Gulf World marine park (partly visible in the background above).

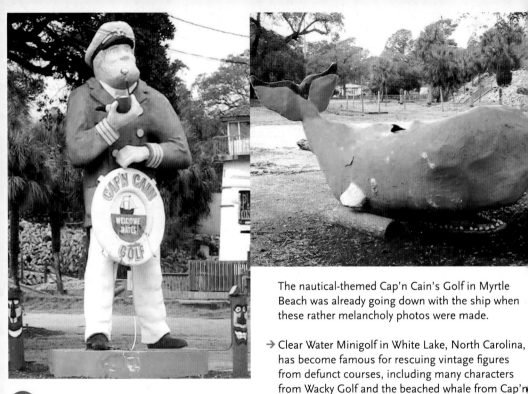

The nautical-themed Cap'n Cain's Golf in Myrtle Beach was already going down with the ship when these rather melancholy photos were made.

→ Clear Water Minigolf in White Lake, North Carolina, has become famous for rescuing vintage figures from defunct courses, including many characters from Wacky Golf and the beached whale from Cap'n Cain's.

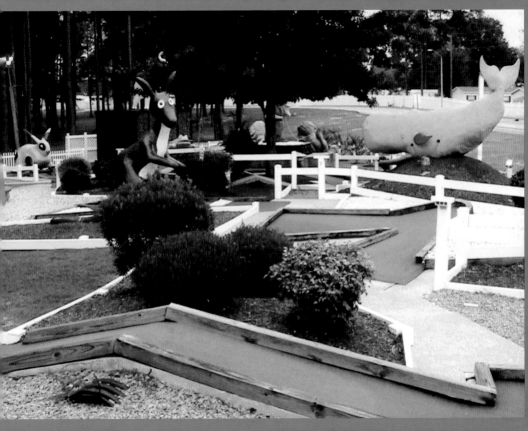

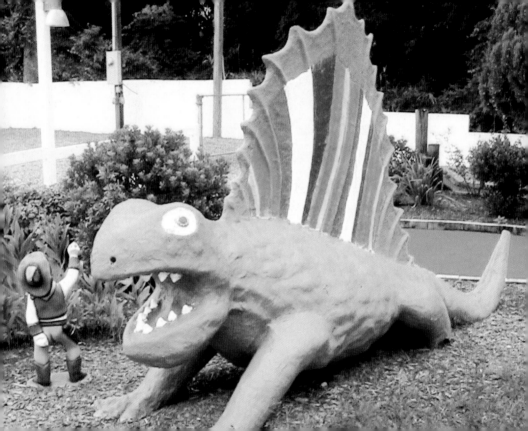

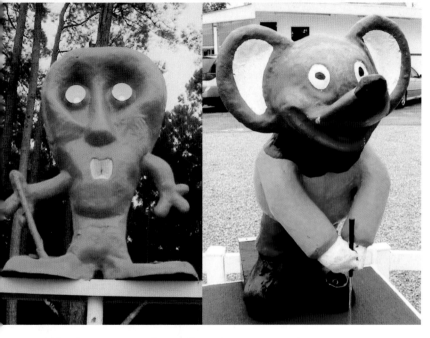

Other ex-Wacky Golf wackos now spending their retirement years at Clear Water include a mouse formerly known as Mickey, and a "Wacky Man" whose relatives once haunted Goofy Golf (page 68).

← Look back at page 62 and you will see this dimetrodon in his original job at Myrtle Beach's Wacky Golf.

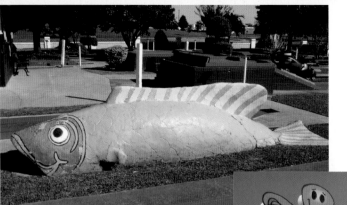

→ Modern Sidwell courses can usually be identified by their signature giant octopus with spreading tentacles, while towering castles on hilltops frequently add background to the scene.

↑ Funland Park in Decatur, Alabama, also has its share of retired concrete citizens. The original home school of this colorful fish is unknown, but at least he still has class.

→ The Sidwell family of Jolly Golf fame now has several Adventure Golf courses around the country, with the classic dinosaurs front and center.

ADVENTURE GOLF

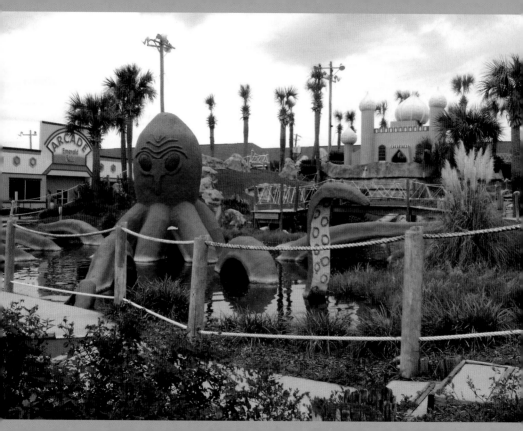

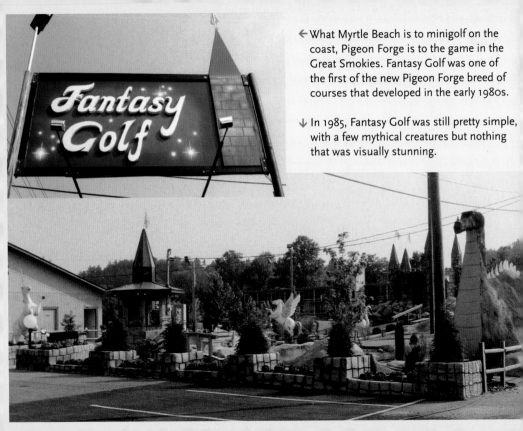

← What Myrtle Beach is to minigolf on the coast, Pigeon Forge is to the game in the Great Smokies. Fantasy Golf was one of the first of the new Pigeon Forge breed of courses that developed in the early 1980s.

↓ In 1985, Fantasy Golf was still pretty simple, with a few mythical creatures but nothing that was visually stunning.

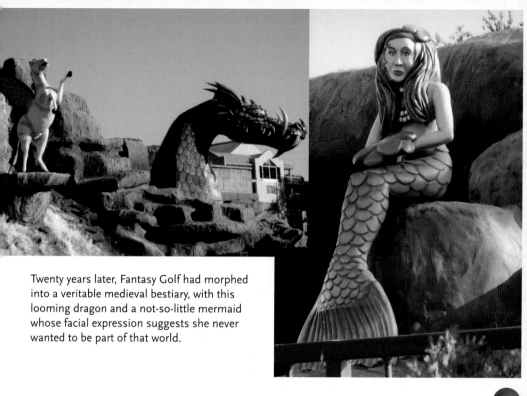

Twenty years later, Fantasy Golf had morphed into a veritable medieval bestiary, with this looming dragon and a not-so-little mermaid whose facial expression suggests she never wanted to be part of that world.

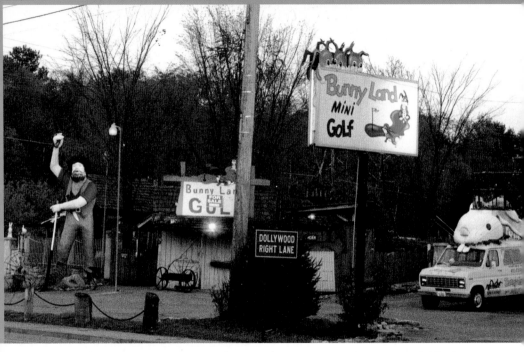

At Pigeon Forge's Bunnyland Minigolf, players putted while surrounded by dozens of live rabbits. The story took a hare-raising turn when, one morning, all the Bugses and Brers were found slaughtered in their cages. It looked like the cotton-tailed end for Bunnyland—or was it?

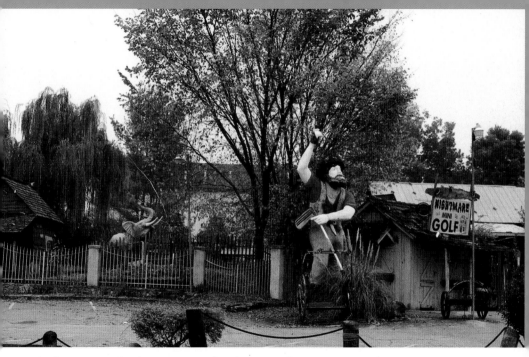

The former Bunnyland soon reopened under a most fitting name considering its past: Nightmare Minigolf. Its prime location near the entrance to the Dollywood amusement park was not enough to make people want to visit that nightmare, though.

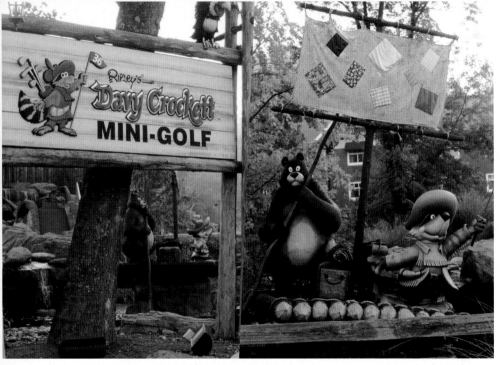

Davy Crockett Minigolf sits on the same Gatlinburg property where the first Jolly Golf laughed its last. The characters on the course are somewhat reminiscent of both Disney's *Song of the South* and Walt Kelly's *Pogo* comic strip.

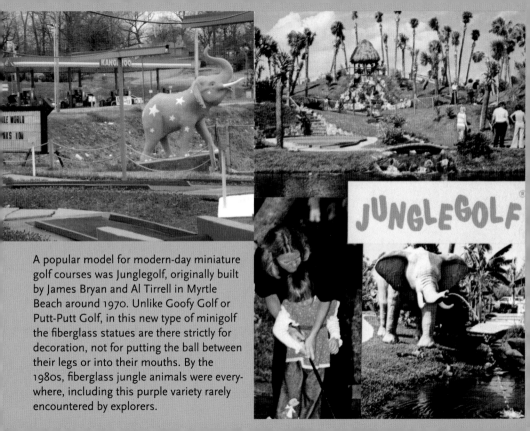

A popular model for modern-day miniature golf courses was Junglegolf, originally built by James Bryan and Al Tirrell in Myrtle Beach around 1970. Unlike Goofy Golf or Putt-Putt Golf, in this new type of minigolf the fiberglass statues are there strictly for decoration, not for putting the ball between their legs or into their mouths. By the 1980s, fiberglass jungle animals were everywhere, including this purple variety rarely encountered by explorers.

JUNGLE SAFARI GOLF

The Black Pearl
GOLF · ARCADE

MOLTEN MOUNTAIN MINIATURE GOLF

OPEN DAILY
LOCALS SPECIAL
INDOOR 18 HOLE COURSE
BEAT THE WEATHER
BOOK YOUR PARTY
WITH US

NOW

MAYDAY GOLF

MAYDAY! MAYDAY!

OPEN DAILY
10 AM

2 18 HOLE COURSES

Mutiny Bay Golf
Caribbean Adventure

OPEN DAILY
PIRATE SHOW
EVERY 30 MINUTES
TWO 18 HOLE
ADVENTURES

RAINBOW FALLS GOLF

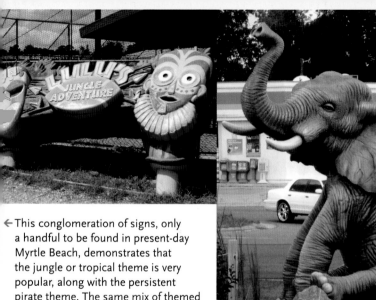

← This conglomeration of signs, only a handful to be found in present-day Myrtle Beach, demonstrates that the jungle or tropical theme is very popular, along with the persistent pirate theme. The same mix of themed minigolf courses can be found in other heavily visited resort areas too.

Even smaller courses got in on the jungle craze, such as Lulu's Jungle Adventure alongside U.S. Highway 90 in Marianna, Florida.

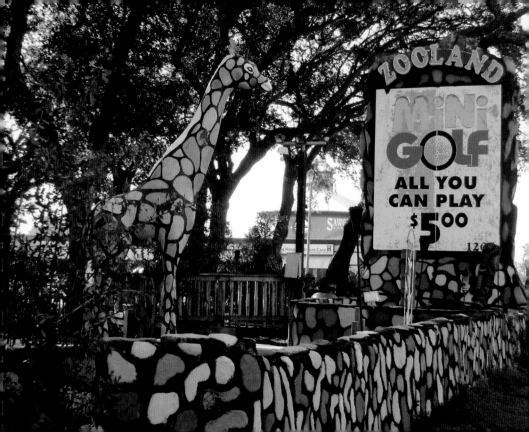

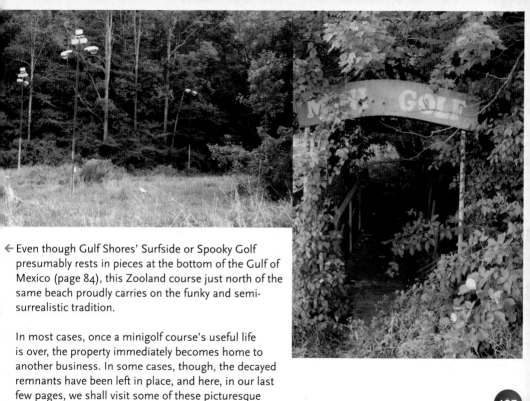

← Even though Gulf Shores' Surfside or Spooky Golf presumably rests in pieces at the bottom of the Gulf of Mexico (page 84), this Zooland course just north of the same beach proudly carries on the funky and semi-surrealistic tradition.

In most cases, once a minigolf course's useful life is over, the property immediately becomes home to another business. In some cases, though, the decayed remnants have been left in place, and here, in our last few pages, we shall visit some of these picturesque ruins.

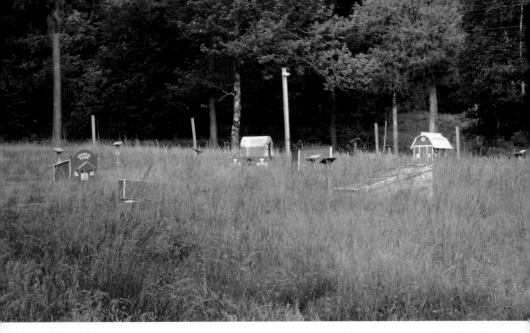

In 2011, these Lomma obstacles could barely be seen peeking out of an overgrown field near Mena, Arkansas.

→ In Cave City, Kentucky, Golgotha Biblical Minigolf was, shall we say, rather unusual even before it was a ruin.

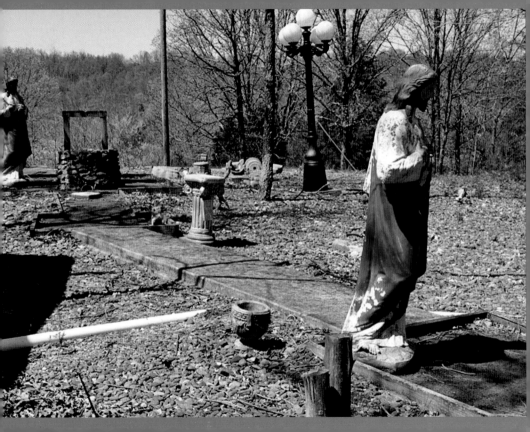

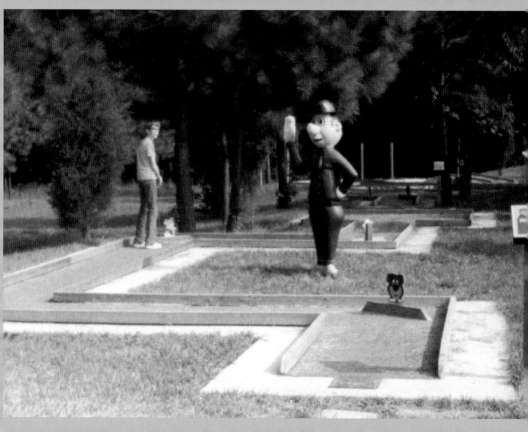

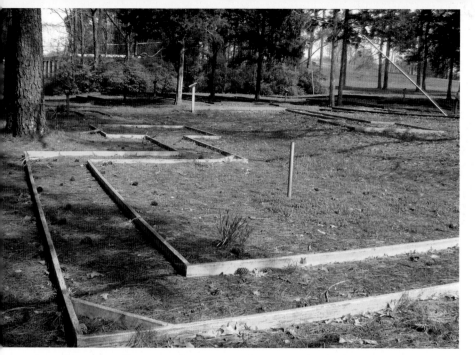

One of the many Jellystone Park Campgrounds was in Guntersville, Alabama. Here you can compare how it looked in 1975 and then in 2012, when the carpet was long gone and only a solitary pipe in the ground marked the former position of Yogi Bear's nemesis Ranger Smith.

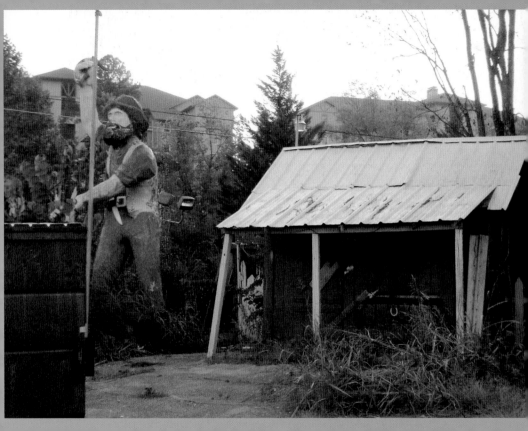

Back on pages 100–101 we saw the tragic story of Bunnyland,
a.k.a. Nightmare Minigolf, in Pigeon Forge. It seems fitting that
in 2011 the ill-fated course was a crumbling wreck.

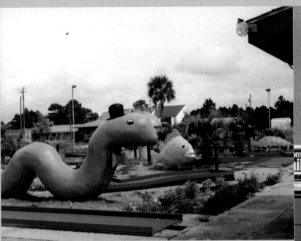

One of the forgotten courses of Panama City Beach was Beacon Golf, named for the lighthouse that was its primary roadside lure. A few colorful characters pepped up the otherwise ordinary design.

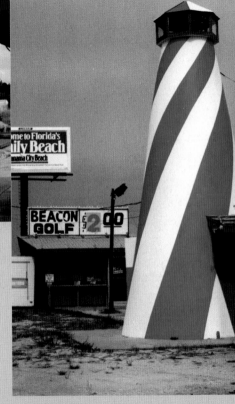

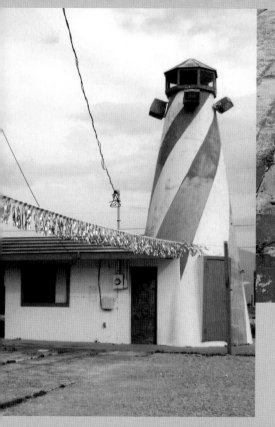

For whatever reason, the Beacon Golf lighthouse still exists, most recently serving as a barbecue stand. The rest of the course and the statues have been plowed up except for what was once fairway number one.

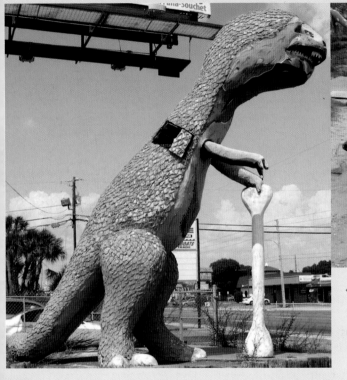

← In an amazing number of cities, the Goonysaurus from Sir Goony Golf has survived as the last memorial of one of that franchise's locations. This particular example maintains a lonely vigil in St. Petersburg.

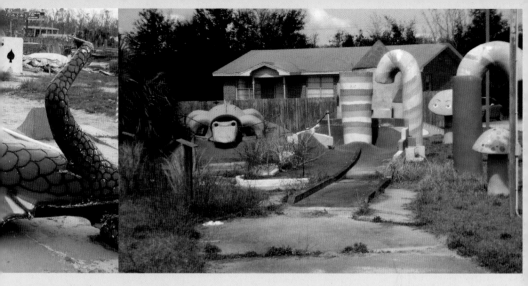

↑ Not all courses are destroyed on purpose. This was the sad condition of Biloxi's Fun Time Golf (page 86) after the unwelcome visit of Hurricane Katrina in 2005.

↑ In the spring of 2014, Pensacola's Goofy Golf— with its interpolated residents from Sir Goony Golf—appeared to have been abandoned for some time. There was still hope for it to be reclaimed from encroaching ruin, but time was running out.

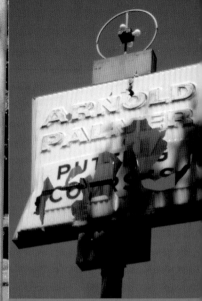

A crumbling Arnold Palmer Putting Course in Birmingham, Alabama can still be seen in front of a once-thriving swimming facility known as the Cascade Plunge.

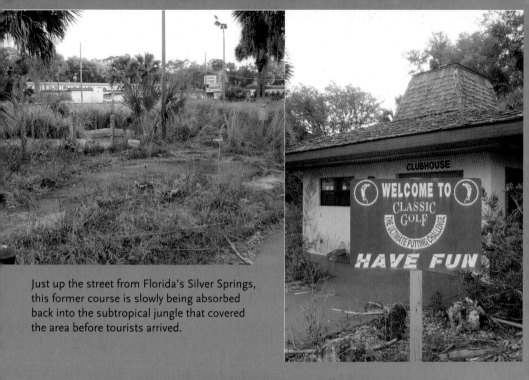

Just up the street from Florida's Silver Springs, this former course is slowly being absorbed back into the subtropical jungle that covered the area before tourists arrived.

CLUBHOUSE

WELCOME TO
CLASSIC
GOLF
THE ULTIMATE PUTTING CHALLENGE
HAVE FUN

No matter how the styles change, from Tom Thumb Golf to Goofy Golf to today's landscaped, jungle-themed courses, it appears that miniature golf will never completely disappear into that bottomless eighteenth hole.

ALL FIRST SHOTS
IN SNAKES MOUTH
GETS FREE PASS

TIM HOLLIS is the author of twenty-five books chronicling various aspects of popular culture and history, including *Hi There, Boys and Girls! America's Local Children's TV Programs*, *Mouse Tracks: The Story of Walt Disney Records*, *Selling the Sunshine State: A Celebration of Florida Tourism Advertising*, and *Ain't That a Knee-Slapper: Rural Comedy in the Twentieth Century*.